CELTIC CALLIGRAPHY

Vivien Lunniss

Gill & Macmillan

First published in Great Britain 1999 by
Search Press Limited
Wellwood, North Farm Road,
Tunbridge Wells, Kent TN2 3DR

Published in Ireland 1999 by
Gill & Macmillan.
Hume Avenue, Park West, Dublin 12
with associated companies throughout the world
www.gillmacmillan.ie

Reprinted 2000, 2002, 2004, 2006, 2010, 2012

Text copyright © Vivien Lunniss 1999

Photographs by Search Press Studios
Photographs and design copyright © Search Press Ltd. 1999

ISBN 978 0 7171 3044 3

Suppliers
If you have difficulty in obtaining any of the materials and
equipment mentioned in this book, then please write to the
Publishers at the address above, for a current list of stockists,
including firms who operate a mail-order service.

I would like to acknowledge the support and encouragement
of my husband, Jeremy, without whom no calligraphy would
have been possible, let alone this book. Also, my lovely, and
sometimes very patient children, Jessica, Jake and Liam.

I am especially grateful to the following:

A. P. Watt Ltd, on behalf of the Royal Literary Fund, for kind
permission to reproduce the G.K. Chesterton quote that
appears on page 45

The Beinecke Rare Book and Manuscript Library, Yale
University Library, for permission to reproduce the
manuscript on page 6

Sue Cavendish, Hon. Sec. of CLAS for permission to
reproduce 'Where to See Historical Manuscripts' from CLAS
journal, *The Edge*

The Dean and Chapter of Durham for permission to
reproduce the manuscripts on page 7

Gillian Hazeldine for her valuable tuition and constructive
criticism

Sue Hinder for loaning the Hindu Cradle Song on page 43

Viva Lloyd for her assistance with knotty problems, the heart
and bird motifs on pages 24 and 25, and the knotwork border
on page 26

Penguin Books for permission to reproduce 'I Have News for
You' from *A Celtic Miscellany*, Kenneth Hurlstone Jackson,
Penguin Books, 1971

Peter Thornton for his instruction, help and advice, and
artwork on page 45.

Mark Van Stone, whose book succeeded in teaching me basic
knotwork patterns where countless others had failed

John Winstanley of Blot's Pen and Ink Supplies, 14 Lyndhurst
Avenue, Prestwich, Manchester, for his help with the
materials on pages 8, 9 and 10

My colleagues and tutors on the Advanced Training Scheme
for their friendship and encouragement

The calligraphers who generously contributed to the gallery

Last but definitely not least, my students, who I am sure have
taught me more than I have ever taught them, and especially
Pamela Finney whose unstinting help with the artwork on
page 24 was much appreciated.

Colour separation by Graphics '91 Pte Ltd, Singapore
Printed in Malaysia by Times Offset (M) Sdn Bhd

Publishers' note
All the step-by-step photographs in this book feature
the author, Vivien Lunniss, demonstrating how to
create Celtic calligraphy. No models have been used.

There is a reference to sable hair brushes in this book.
It is the publishers' custom to recommend synthetic
materials as substitutes for animal products wherever
possible. There are now a large number of brushes
available made from artificial fibres and they are just as
satisfactory as those made from natural fibres.

Contents

NTRODUCTION

The art of formal writing, from the movement of the pen on the paper, to the sensual curves of the letter forms and the meanings of the words themselves is a constant source of pleasure to me. My skills and confidence have grown after many years of practice and discipline. These skills, when combined with periods of 'play' and experimentation, have led me to discover a seemingly endless source of creative and expressive possibilities for calligraphy. It is possible to give words a different meaning or emphasis simply by changing the way they are written – just as we can alter the spoken word by changing inflection.

We use the familiar abstract shapes that we call our alphabet on a daily basis often without thinking about their origin. They are the result of a long period of evolution, punctuated by periods of great beauty and consummate skill. It is to these roots and traditions that we should initially return for our calligraphy.

The isolated monastic life created centres of calligraphic and artistic expertise and produced books and documents essential to the life of a religious community. A scriptorium in Ireland or Northern Britain in the seventh century had no television, telephone or fax machine to interrupt scribal flow, and the scribes were not able to pop out to their local art shop for supplies. Instead there was the daily ritual of quill cutting, vellum preparation, and pigment grinding and mixing, which resulted in the creation of manuscripts which were intended as a testament of faith and love of God by their makers.

Today, whilst we marvel at the beauty and skill displayed by the scribes and mourn the loss of the majority of manuscripts, decimated by Scandinavian raids, we can learn to recreate these letter forms in our own way, taking pride and pleasure in our work as we renew old skills, or take up the broad-edge pen for the first time.

This book lays the basic foundations for Celtic lettering and decoration, with an emphasis on the rich historical traditions behind our alphabet. Letter variations are also demonstrated, which can be practised once you have acquired some of the basic skills. These will lend a more contemporary look to your work.

House Blessing

177 x 283mm (7 x 11¼in)

This piece of calligraphy incorporates decorated letters adapted from the great masterpieces of medieval art: the Book of Kells *(Irish, seventh century), and the* Lindisfarne Gospels *(North-East England, late seventh century). It is worked on artificial parchment using non-waterproof Indian ink and gouache.*

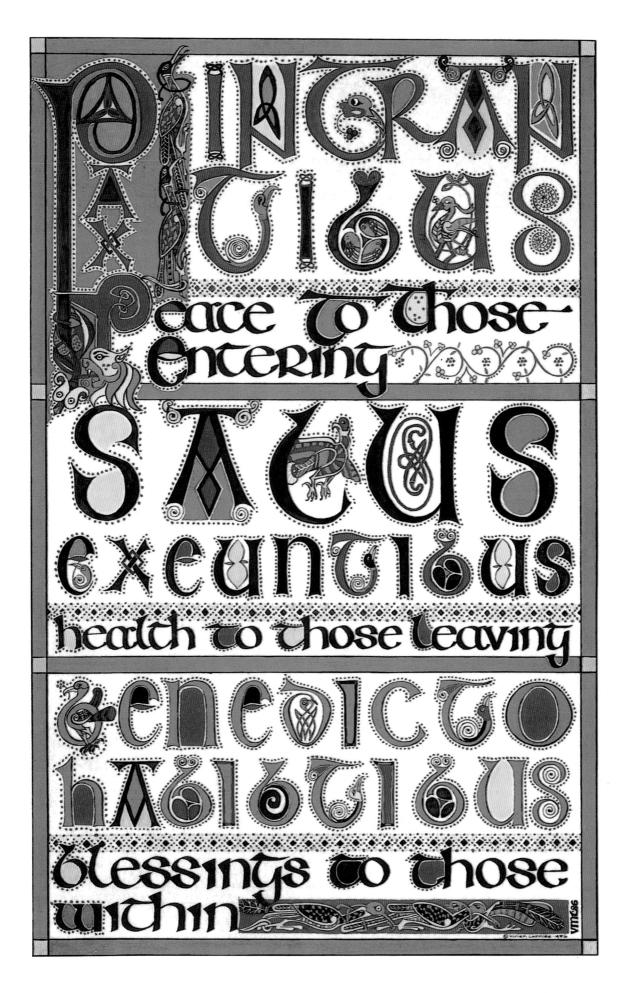

PINTRANTIBUS

Peace to those entering

SALUS EXEUNTIBUS

health to those leaving

BENEDICTO HABITIBUS

blessings to those within

Looking at Historical Manuscripts

The Celtic style of lettering more correctly belongs to the uncial family of letters. These were commonly used in Christian books between the fourth and eighth centuries, although their use persisted as headings long after this.

The hand developed in the Roman empire during the fourth century and was widely used. Regional variations emerged, and three examples are shown here.

The evolution of our writing system has been heavily influenced by the writing surfaces and implements used. Uncials are often referred to as a 'true penman's alphabet' because their round and legible form is the direct result of writing with a broad-edge pen held at a natural angle – earlier formal scripts largely imitated inscriptional forms.

The important thing to note is that uncials are a majuscule, or capital script. Initials were a larger size of the same letter. Uncials were in use before the distinction between upper and lower case, as we know them, emerged. This was the result of a process which began around the seventh century, and was complete by the ninth. These manuscripts were not intended as exemplars, and therefore contain natural variations in the writing.

Please refer to the bibliography for places to see manuscripts from this period.

Note We owe our ability to understand historical scripts to the pioneering work of Edward Johnston who, at the beginning of this century, rediscovered the techniques of the broad-edge pen. He developed scripts and designed typefaces based on his studies of manuscripts in the British Library. He determined seven main factors that we need to know for a proper understanding of formal letters:

1. Angle of pen to horizontal writing line
2. Width of strokes in relation to height of letter
3. Form and basic structural shape of letters, especially 'o'
4. Number of pen strokes
5. Order of pen strokes
6. Direction of pen strokes
7. Slope of writing

This information is given for the three manuscripts shown here, demonstrating that it is possible to reproduce the script by working through the checklist.

Natural Uncial

Natural uncials are quicker to write than inscriptional-style capitals. Here, some letters run into the next and some strokes are not completely joined. The pen angle is almost flat (see diagram) on the vertical strokes, but the curved ones have an angle of about 10°. The ascenders and descenders are unusually long.

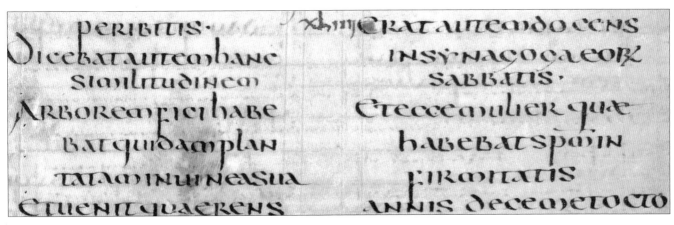

Gospel of St Luke • *Fragment* • *Italy* • *Fourth quarter of the seventh century* •
Beinecke Rare Book and Manuscript Library, Yale University

Artificial Uncial

This is expertly written, beautifully sharp and strong lettering. It is written throughout with a flat pen angle. The serifs on 'E', 'T' and 'N' are made by manipulating the pen to use one corner. A flat pen angle is more easily achieved with a right-oblique pen.

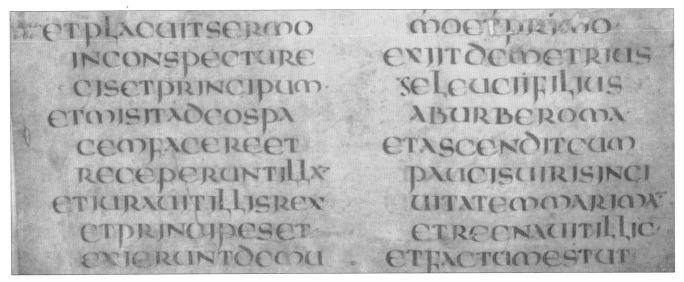

Libri Maccabaeorum • Italy • Sixth century • The Dean and Chapter of Durham

Insular Majuscule

Insular actually means 'of the British Isles'. Here, the word 'Marcus' is splendidly ornamented. The bowls of 'M' are filled with birds' heads and knotwork. The counterspaces (see page 12) are coloured, and the whole word is surrounded with a border of red dots. Expertly written with a flat pen angle, the script is characterised by the heavy wedge serifs. Having run out of space on the last line, the scribe has placed the remaining letters vertically.

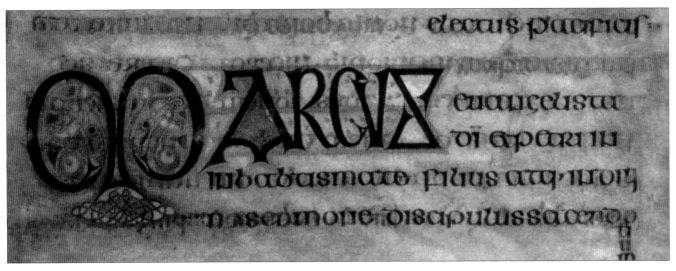

Evangelia • Probably written in Northumbria in the Irish tradition •
Eighth century • The Dean and Chapter of Durham

Materials and Tools

The basic essentials for calligraphy are pens, paper and ink. Whilst the quill and reed pen were the original writing tools, manufactured pens are now readily available.

Pens

The selection of nibs and holders is very much a personal one. Pen holders are available in different materials and fit most nibs. There is a wide range of broad-edge fountain pens available; these are useful for practice and ephemeral pieces. Dip pens are really most suitable for formal calligraphy. New nibs can have a thin coating of oil from the manufacturing process; this needs to be removed before use by rinsing with hot water.

Periodically while you are working and immediately you have finished, dip the pen into a **rinsing pot (14)** as if you were filling with ink and wipe dry, preferably with a **cotton cloth (6)** as paper tissues can leave fibres on the pen. Avoid total immersion of both nib and holder as the metal ferrule of the holder will corrode.

You will also find black or coloured **technical drawing pens (10)** useful for outlining and for tracing images.

Inks

Best results are obtained with a good quality **non-waterproof Indian ink (12)**. This can benefit from the addition of a little lamp black gouache and **gum arabic (1)** – the former will make the ink denser, and the gum arabic will reduce the risk of smudging once the ink is dry. Although these inks are non-waterproof, they are not completely washable and can leave a stain. Be careful not to buy waterproof drawing ink as this contains shellac which will clog the pen. There is now a wide range of coloured inks available in addition to black.

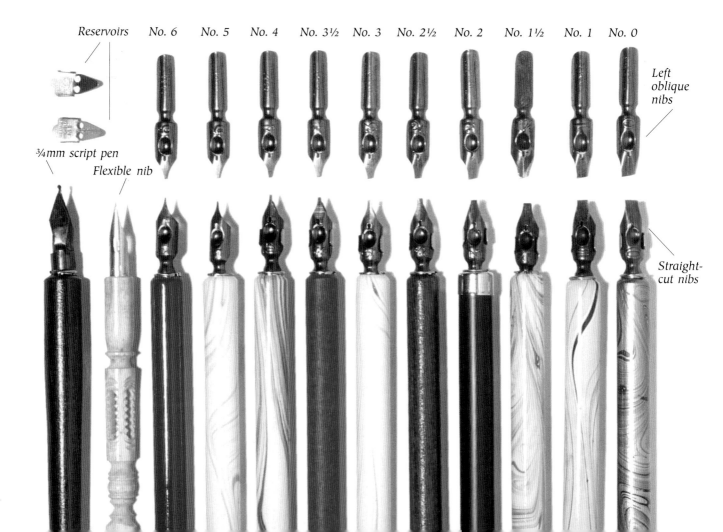

Reservoirs No. 6 No. 5 No. 4 No. 3½ No. 3 No. 2½ No. 2 No. 1½ No. 1 No. 0

¾mm script pen

Flexible nib

Left oblique nibs

Straight-cut nibs

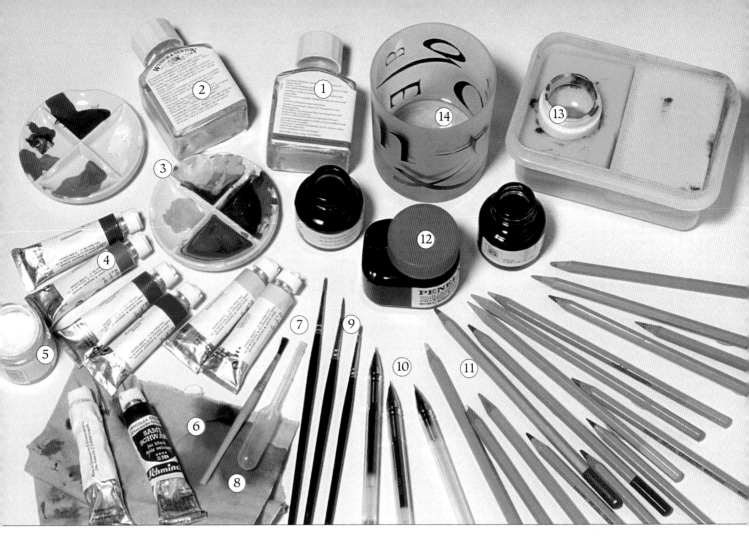

Paints

The ideal material for decoration and writing in colour is **gouache (4)**. This is available in an extensive range of colours and many more can be mixed from a basic palette. The manufacturer's product description specifies the covering power, light-fastness and staining properties. Artist's quality will give the best results. **Process white (5)** is useful for correcting mistakes, and a few drops of **oxgall liquid (2)** will assist the flow of gouache mixes.

Brushes

A small **children's paintbrush (7)** is inexpensive and ideal for mixing colours and filling the pen.

For painting, use a good quality **kolinsky sable (9)**. These brushes have a very good point for detailed work.

The size determines the amount of paint the brush will hold. I usually use a No. 1, although for painting larger areas I would use a No. 4 or No. 8. These brushes can be expensive, but with care they will last for years. Always test the point before buying a paintbrush. To do this, dip the brush in water and then shake it, like shaking down a thermometer. If it is a good quality brush, the point should be restored.

To care for your paintbrush, protect it with the cover provided when it is not in use. Do not use it for mixing your colours. Rinse it immediately after use, but never scrub it around the bottom of your water jar, as you will soon damage the delicate hairs. Finally, restore the point before covering.

Coloured Pencils

Watercolour pencils (11) are useful for colouring motifs.

Palette

Ceramic palettes (3) are best for mixing colours in. The container needs to be white, so that you can see the true value of your colours. Unused paint can be kept covered and used again.

I decant ink into a **shallow container (13)** and support this with foam to prevent it from tipping when I am working.

Paper

Even practice paper needs to produce sharp lettering, and **layout paper (2)** is very good for this purpose. For finished work, there is an enormous range of lovely papers to choose from. **Cartridge paper (5)** is probably the cheapest. **Pastel paper (7)** is available in a range of colours, and **watercolour paper (4)** is also very good. Watercolour paper should have a hot pressed (HP) finish which provides a smooth surface for writing. The **Indian handmade papers (8)** are popular for calligraphy because of their subtle colours and textures.

The thickness of the paper is described by its weight, either in lbs (pounds) or gsm (grams per square metre), so the higher the number, the heavier the paper. If you are doing a lot of painting or applying a watercolour wash, a lightweight paper would need stretching, or the amount of water used may cause it to cockle. A heavyweight paper does not require stretching.

Your choice of paper is very much part of the design process, and its colour and surface finish will make an important contribution to the overall design. Do not be afraid to experiment with different papers, and work with better quality paper as a matter of course, otherwise you may find yourself suffering from a form of calligraphic stage fright common amongst students who try to save their best paper until they are 'good enough' to use it. As calligraphy is a combination of pen, paper and pigment, a change in one will affect the others. Keep swatches and samples for reference.

Scrap paper (9) and **tracing paper (1)** are always useful and strips of **black card (10)** are invaluable for setting margins.

Drawing Equipment

It is essential to have some means of measuring and ruling guidelines for writing. A pair of **lockable dividers (18)** and a **parallel ruler** (not pictured) would be ideal, a **460mm (18in) T-square (24)** or **ruler (25)** would be a suitable alternative. A large **set square (23)** is used for ruling in margins.

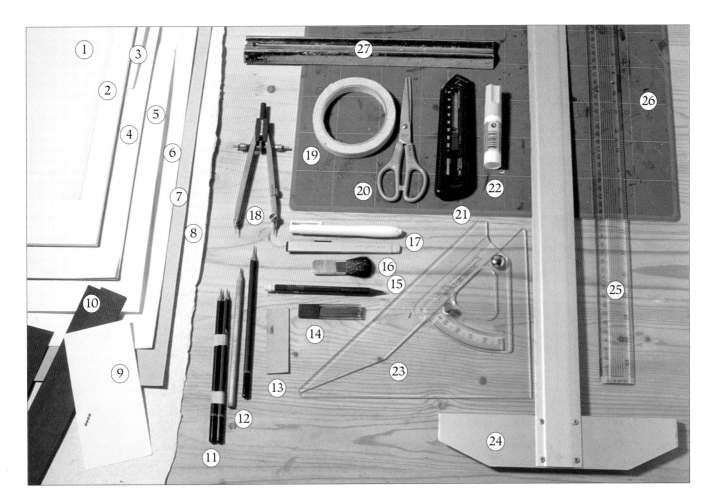

You will also need **pencils (12)** of varying hardness for ruling lines and tracing illustrations. A sandpaper block will keep them sharp **(13)**. **Propelling pencils (15)**, and their **leads (14)** are a convenient alternative. **Two pencils taped together (11)** form a double-edged writing tool, used for learning the principles of the broad-edge pen, and for drawing larger letters.

The medieval scribe was quite happy to leave the lines in on his work, and early printed books often had lines ruled in after printing to mimic the handmade version. Nowadays, convention dictates that lines are erased after writing **(17)**. A **soft brush (16)** will deal with the debris.

Scissors (20), **cutting mat (26)**, **craft knife (21)**, **metal ruler (27)**, **masking tape (19)** and **repositionable glue (22)** have all been used in the projects later in the book.

Commercial drawing board with an adjustable angle.

Drawing Board

Medieval miniatures of scribes at work always show them using a sloping desk. The advantages of this are that a slope allows greater freedom of movement of hand and arm. Also, if your work is correctly positioned, the view of your writing is not obstructed by your hand, and you are able to sit upright and avoid back strain. In addition, the ink flow from the pen is affected by the slope, and therefore greater control can be achieved.

Commercially available drawing boards can be purchased, but it is also possible to construct one yourself, using the deckchair principle for raising the height of the board. Alternatively, you can use a sheet of hardboard approximately A2 size (24 x 18in). This can rest on your lap and form the required angle against the edge of the table, or be propped against a pile of books.

Whichever method you use, the board will need to be covered with about eight sheets of an inexpensive **drawing paper (3)** and a final layer of **blotting paper (6)** to provide a sympathetic writing surface. The sheet you are writing on will need to be moved, much like a typewriter, so your writing position does not alter appreciably. It is very important to use a guard sheet under your hand, to keep the paper clean and free of oils.

An alternative to the adjustable commercial drawing board is to lean the board against the table, with the base in your lap . . .

. . . or to lean the board against a pile of books.

Basic Principles

Just as you would not be able to make a cake by looking at a picture of one in a cookery book, so you need to understand the ingredients of the script you are studying (or in calligraphic terms, how it is constructed) before you can produce it. Exemplars are provided as a guide to how the script should look, but these are not intended to be copied slavishly. The aim is to capture the spirit of the script. Copying without understanding can produce results which lack the strength of the original.

It is important to learn the formation of the letters to enable you to write fluently and accurately. Begin by familiarising yourself with the equipment and principles of penmanship in order to achieve a greater understanding of the scripts concerned. These basic principles are applicable whichever calligraphic style you choose to study later.

There are two main characteristics of broad-pen lettering: the first is that thick and thin strokes are brought about by the use of a broad-edge pen held at an angle to a horizontal writing line; the second is that letters are generally built up from a sequence of strokes with the pen travelling in a left to right, and top to bottom direction. There are not usually any joining strokes (ligatures) between broad-pen letters, unlike handwriting which is more economical in terms of movement to achieve the necessary speed.

The finished pen-made letter is the product of three variables known as weight, angle and form.

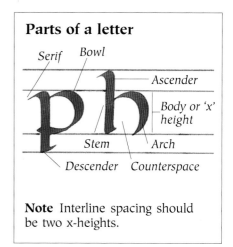

Parts of a letter

Serif Bowl Ascender Body or 'x' height Stem Arch Descender Counterspace

Note Interline spacing should be two x-heights.

Weight

Whether the texture of a script appears overall to be heavy or light is determined by the ratio between the width of the nib and the height of the writing line. Nowadays, this is most often referred to as the x-height, a term borrowed from typography.

Heavyweight letter 3 nib widths *Lightweight letter 10 nib widths*

Angle

Because the pen has a broad edge, the angle that this edge makes to the writing line will affect the shape of the pen stroke. The pen angle controls the distribution of the weight around the letters, and it should be consistent throughout the pen strokes. Most scripts have a specified pen angle.

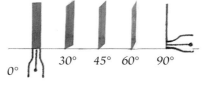

*The **flatter** the pen angle the **fatter** the vertical line becomes. This has a profound effect on the shape of letters*

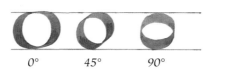

Form

All calligraphic letters have an underlying structure or form which is usually based on the shape of the 'O'. This letter is sometimes referred to as 'the mother of the alphabet'. This shape is common to other letters and thus unifies the alphabet.

Uncial form, slightly wider than its height

Roundhand, based on two overlapping circles

Italic form, based on an oval, often with a forward slant

Ruling Up

Ruling up parallel guidelines for your writing is an essential but often neglected element of calligraphy. To help you write fluently and consistently, guidelines should be precisely measured and drawn using a well-sharpened pencil or propelling pencil. An HB hardness will allow you to rule lightly without scoring the paper, and will be easy to erase later. Always start with a larger sheet of paper than needed and allow generous margins. Double check your measurements, and for finished work, rule up some spare sheets in case of mistakes.

> **Note** Ensure that you have a good light source when you are working – either a window, or a daylight bulb in a desk lamp. If you are right-handed, the light should be directed from the left; if left-handed, from the right.

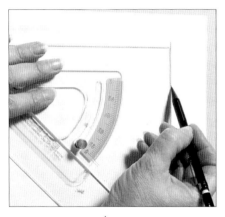

1. Rule a line at the top of the paper then use a set square to rule lines on the left- and right-hand sides. This will give you your margins to work within.

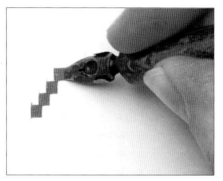

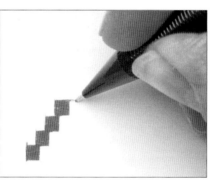

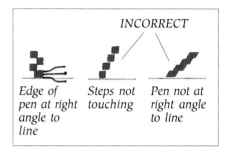

2. Make a note of the nib size on spare paper for future reference. Use your nib to mark four steps, ensuring that the nib is exactly at right angles to the horizontal and that the steps are touching.

3. Place a small paper strip next to the steps and mark off the top and bottom points. (Note: You could use dividers to measure this if you prefer.)

4. Use the marks on the paper strip made in step 3 to mark the x-height down both vertical margins, starting from the top ruled line. Continue down the page for the required number of lines. If you are using dividers, 'walk' them down the page, pricking the paper as you go.

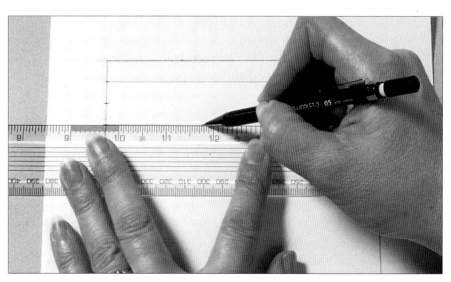

5. Use a ruler and pencil to draw lines across the paper, joining up the marks. If the interline spacing is two x-heights, then you can miss out every third set of marks.

Using a pencil

This demonstration is designed to help you learn about the shapes of letters before weight is added with the broad-edge pen. Once you have traced them from the exemplar, you can copy them freehand. You need to practice these letters using an HB pencil – this is responsive to use, but it loses its point very quickly. Here, I also show you how to sharpen a pencil properly, so you can overcome this problem.

All alphabets should be considered as a carefully matching set of letters where the basis of its design is usually the letter 'O'. This letter determines the shape and proportions of the other letters. Understanding the skeleton form will help with the letter variations later in the book.

1. Use a craft knife to take off the wood at the top of your pencil, leaving about 12mm (½in) of lead showing.

2. Roll the lead on sandpaper to produce a point. Repeat as soon as the point begins to disappear when you are working.

3. Place a piece of layout paper over the exemplar and secure it in place with masking tape. Trace off the letters so that you begin to learn their shapes, proportions and relationships to one another.

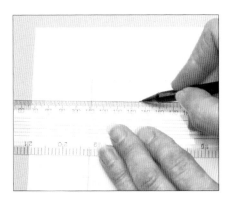

4. Rule up lines approximately the same width apart as the exemplar. Use the same method as shown on page 13.

5. Practice the letters freehand, copying from the exemplar. Work from top to bottom and from left to right in preparation for working with a pen.

6. When you feel confident, reduce the size of the letters and experiment with writing out whole words and sentences.

Skeleton Exemplar

This form is based on a circle which is slightly wider than its height. The grid, shown in red, is a square – when the letters are drawn with their sides just outside the box, they will be the correct width. The letters are in groups of related shapes rather than in alphabetical order. The same strokes recur, therefore instead of writing rows of the same letter, work through in this order, and each letter will reinforce the next. Follow the order and direction of the arrows when drawing the letters.

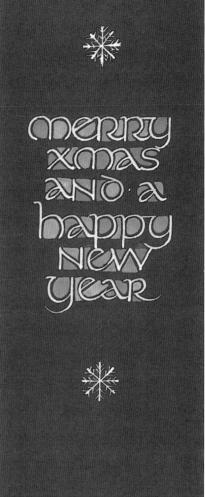

Round Letters

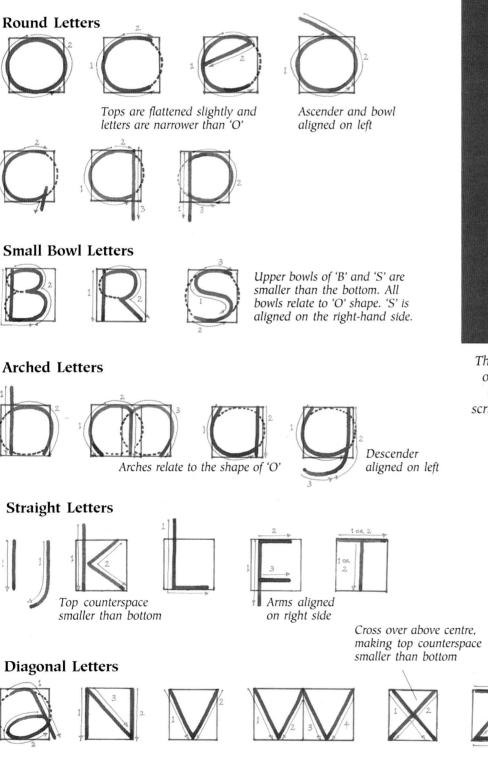

Tops are flattened slightly and letters are narrower than 'O'

Ascender and bowl aligned on left

Small Bowl Letters

Upper bowls of 'B' and 'S' are smaller than the bottom. All bowls relate to 'O' shape. 'S' is aligned on the right-hand side.

Arched Letters

Arches relate to the shape of 'O'

Descender aligned on left

Straight Letters

Top counterspace smaller than bottom

Arms aligned on right side

Cross over above centre, making top counterspace smaller than bottom

First stroke slightly narrower than third

Diagonal Letters

This shows a practical application of the skeleton form on dark blue card using white gouache and a script pen. Counterspaces are filled using gouache.

15

Using a Pen

Before starting to write, you need to familiarise yourself with the action of a broad-edge pen which may be quite different to anything you have written with before. It can also take a little while to become accustomed to filling the pen fairly frequently – the reservoir does not hold a great deal of ink, and a broad nib will exhaust this quite quickly.

You may find it useful to trace the letters from the exemplar a couple of times to familiarise yourself with the shape. Take care to match the pen angle to achieve the right distribution of weight, and follow the order and direction of strokes.

Note If you are left-handed, you may find it easier to work with the paper at an angle.

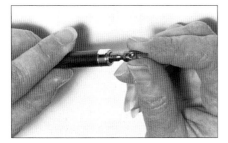

1. Push the nib into the holder as far as it will go. Make sure that it goes between the claws and the outer edge of the barrel.

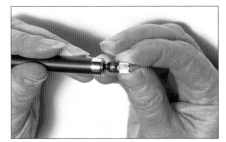

2. Slide the reservoir on to the nib. It should feel firm and the nib should not move about. The reservoir should be tight enough not to fall off, but not so tight that it impedes the nib's flexibility.

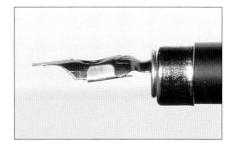

3. Ensure the reservoir is in the correct position, approximately 2mm ($^1/_{16}$in) from the end of the nib and touching the underneath of the nib. The metal is quite flexible and can be adjusted accordingly.

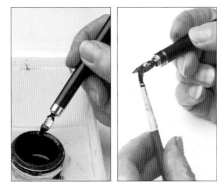

4. Decant the ink into a small, shallow container supported with foam to prevent it from tipping over. Fill the pen by dipping it into the ink no further than the holes in the reservoir. Alternatively, you can load a brush with ink and then stroke it over the reservoir.

5. Move the pen from side to side on a piece of scrap paper to encourage the ink to flow (this is called 'the calligrapher's wiggle'!). You will need to do this whenever you fill the pen, to ensure that it is not overloaded.

6. You are now ready to start writing! Remember to use a guard sheet under your hand to protect the paper as you write.

Exemplar Showing Pen Strokes

The comments on the skeleton exemplar (see page 15) also apply to the pen form. Try and memorise the shape and construction of the letter so that you do not have to look away as you write. Compare each letter with the model and not the last letter that you wrote, or you may repeat your mistakes. Work through all the letters as before, to be sure of reaching 'Z', then none are neglected.

Note There were originally twenty-two letters in the alphabet. The letters 'J', 'K', 'V' and 'W' are a later addition. I give the 'V' and 'W' a slightly rounded base in keeping with the other letters.

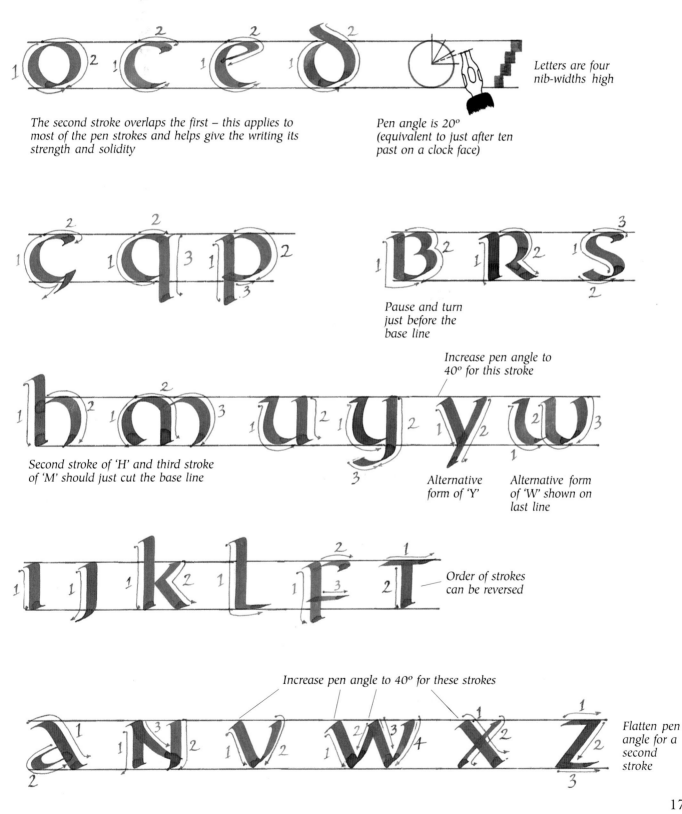

Letters are four nib-widths high

The second stroke overlaps the first – this applies to most of the pen strokes and helps give the writing its strength and solidity

Pen angle is 20º (equivalent to just after ten past on a clock face)

Pause and turn just before the base line

Increase pen angle to 40º for this stroke

Second stroke of 'H' and third stroke of 'M' should just cut the base line

Alternative form of 'Y'

Alternative form of 'W' shown on last line

Order of strokes can be reversed

Increase pen angle to 40º for these strokes

Flatten pen angle for a second stroke

17

Words and Sentences

Once you have learned the formation of the letters and practised the shapes a few times, use them in combinations of words and sentences rather than producing rows and rows of the same letter.

Calligraphy can often be the art of bad spelling, so be prepared for mistakes. A way of avoiding these on finished work is given on page 31.

Note Using your writing in small finished pieces will teach you other aspects of the craft in addition to the lettering. Calligraphy is a skill which improves with use, so commonplace items such as envelopes, letters and greetings cards are a useful means of putting theory into practice.

Alphabet sampler
185 x 80mm (7¼ x 3in)

This sampler is written in gouache using ten different pens. It illustrates the variations in letter size which can be achieved.

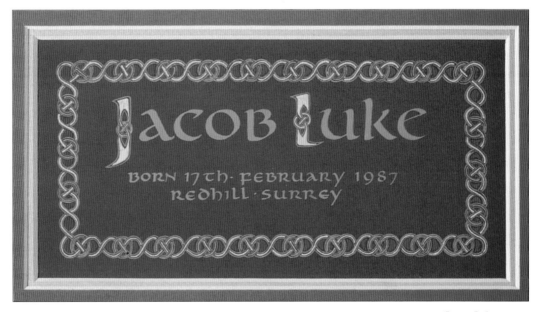

Birth Celebration
150 x 67mm (6 x 2½in)

Written and painted with gouache, on dark blue Ingres paper. Large and small nib sizes bring contrast and dominance to a simple design.

Letter Spacing

Letters need to be positioned so that the overall pattern of writing appears evenly balanced. This is achieved when the space inside the letter is balanced by the space either side of it. Because of the variations in letter shapes, this cannot be an exact science, but 'rule of thumb' guides are always useful to a beginner. Two adjacent vertical strokes should have about two thirds of the width of the counterspace of 'N' between them. Because of its shape, a round stroke should be a little closer to an adjacent vertical, and two round strokes closer again.

To help you develop an eye for balanced spacing, practise words which combine these strokes.

It is often easier to assess your spacing when you are not able to read the words, so try viewing your writing from a distance or upside down.

An adjustment needs to be made for letters with open counterspaces, otherwise this space visually adds to the letter space and can create 'holes' in the text.

Word Spacing

Too much space between words will create vertical 'rivers' of white in a page of writing. Allow no more than the width of 'N' between words.

Alphabet sentences

These alphabet sentences were written to practice letter form and spacing. Small writing can actually be more difficult than large, so reduce the nib size gradually as shown here.

CELTIC DECORATION

Much Celtic decoration was based on interlacing knotwork, spirals and key patterns, and there are many books available which deal with their method of construction (see Bibliography on page 48). In keeping with a more simplistic and contemporary style, these can be adapted and used as borders, motifs or in the stems and bowls of letters.

The letters and borders on the following pages can be enlarged or reduced on a photocopier and traced using the method shown here.

Knotwork

A Celtic knot is made up of one or more strands, and each 'under' must be followed by an 'over' to interlace the strands of the knot. Knotwork can be made to appear three-dimensional by using simple shading techniques, as demonstrated here.

You will need

Technical pens: black and coloured

Soft pencil

Hard pencil

Tracing paper

Masking tape

Eraser

Gouache: purple, white and black

No. 1 kolinsky sable brush

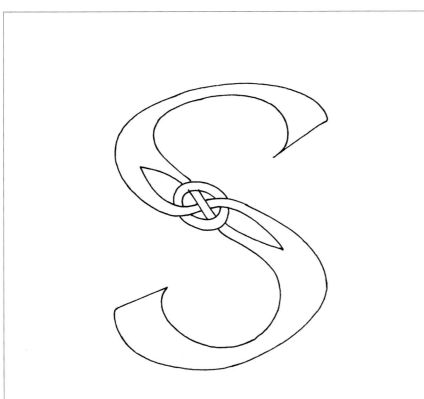

Pattern for the letter 'S'
Adjust the size on a photocopier to suit.

1. Place a piece of tracing paper over the letter and secure in place with masking tape. Trace around the outline with a hard pencil.

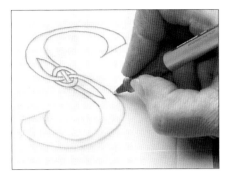

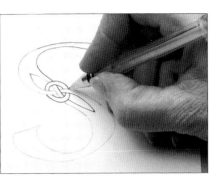

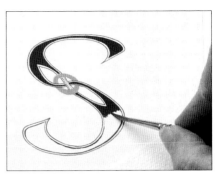

2. Turn the tracing over and go over the back of it with a soft pencil. Now turn it the right way up again and place in position. Secure with masking tape. Go around the outline with a coloured pen to transfer the image. Check it has transferred before removing the tracing.

3. Outline the letter using a black technical pen. Leave to dry before erasing the pencil line.

4. Fill in the knot using a No. 1 brush and pale purple gouache. Fill in the letter using purple gouache. Leave a white moat between the colour and the outline.

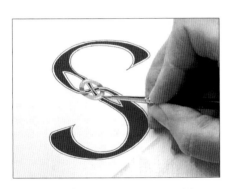

Knot painted flat

Knot painted with shading

5. Use white gouache to add highlights to the knot where the strands pass over one another. Add shadows where the strands go underneath using a darker tone of purple.

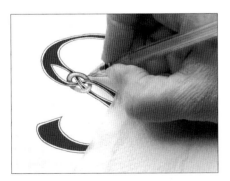

6. Outline the knot with a black technical pen. Touch up the rest of the outline if necessary, to complete the letter.

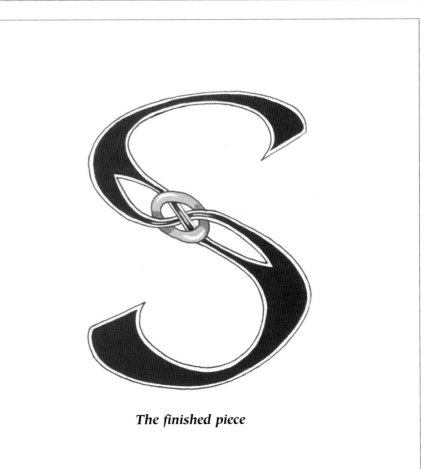

The finished piece

Letters

The simplest form of decorated letter is traditionally written larger than the main text, with the counterspace filled in with a contrasting colour, and the whole letter surrounded by a border of red dots.

Here, the basic shape of 'A', 'B', 'C', 'F', 'H' and 'R' were constructed using two pencils taped together to form a double-edged writing tool. All the letters are painted with gouache, in traditional and contemporary colour combinations.

Some of the designs could be adapted for other letters, and they can also be reduced or enlarged on a photocopier.

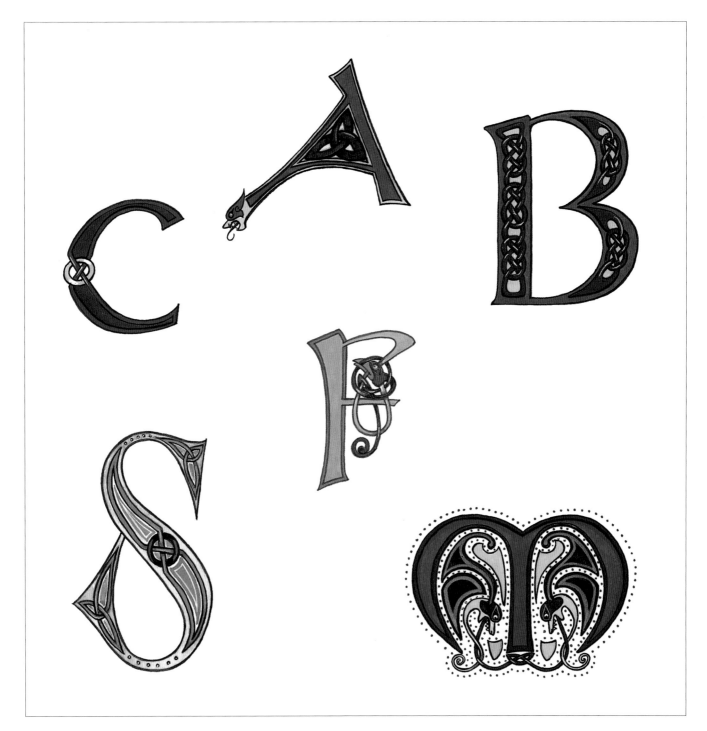

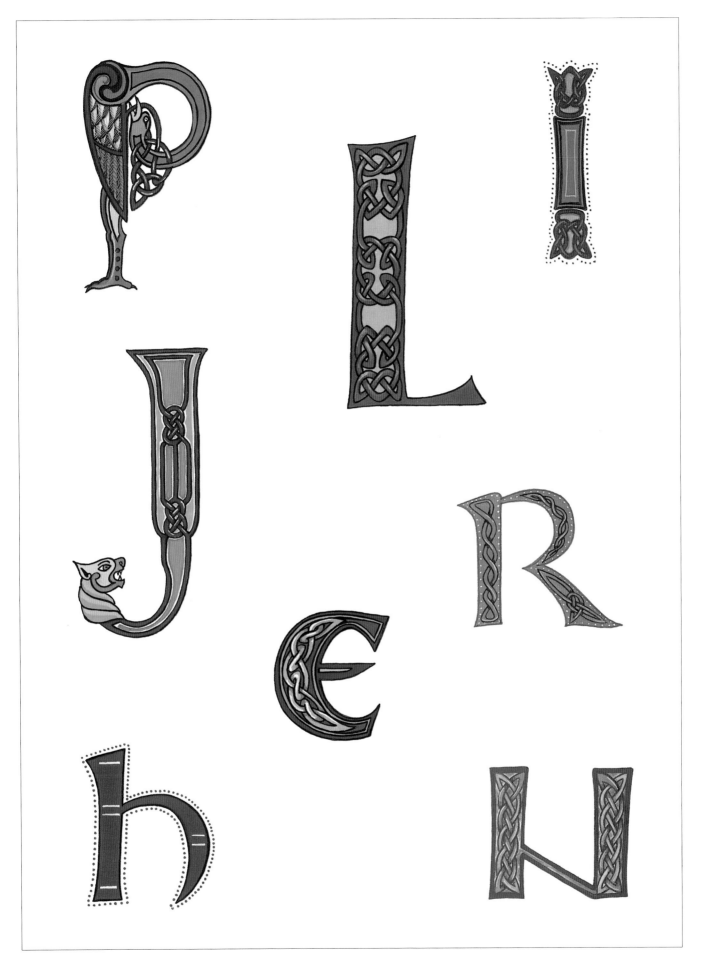

Motifs

The construction of selected motifs is here demonstrated with coloured pens for illustrative purposes. In practice, you should use pencil, which can be erased after the decoration has been drawn and outlined as shown on pages 20–21. The Triskelle knot shown below is a simple knot based on a triangle.

Triskelle Knot

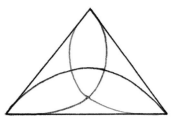

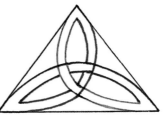

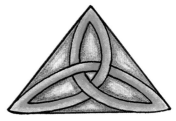

1. Draw three curved lines into the corners of a triangular framework which can have any proportions.

2. Double up on the lines to form strands. There should be a gap in the centre.

3. Weave the strands, ensuring each 'over' is followed by an 'under'. After outlining, erase the pencil and colour with watercolour pencils. The knot can be used with or without a background.

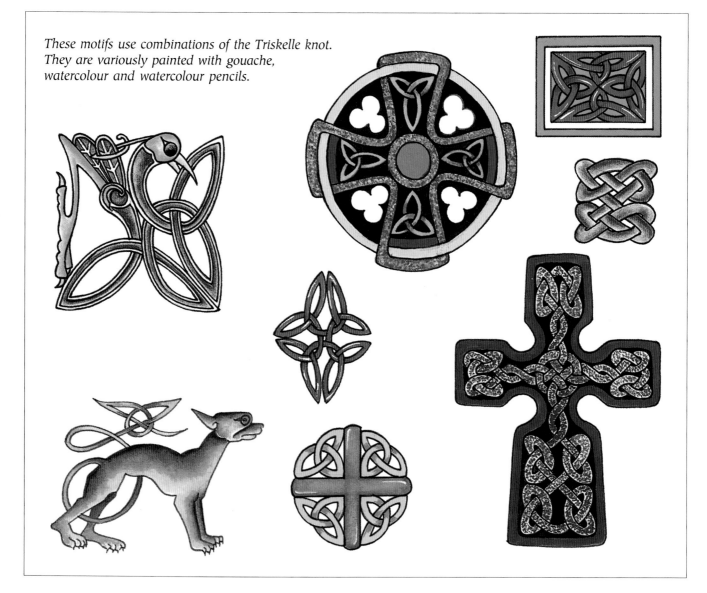

These motifs use combinations of the Triskelle knot. They are variously painted with gouache, watercolour and watercolour pencils.

24

Heart-twining Knot

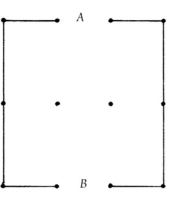

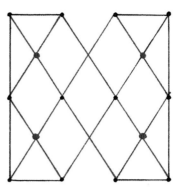

1. Mark out a rectangular grid of 3 x 2 units.

2. Draw walls around, leaving the units at A and B open.

3. Place a dot in the centre of each rectangle and draw a diagonal grid (shown in red).

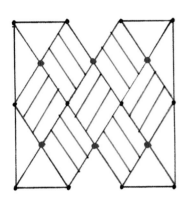

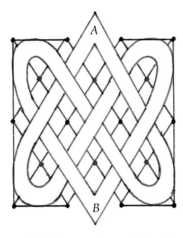

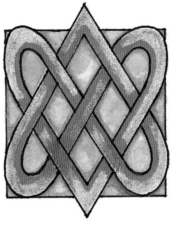

4. Draw a strand (green) inside and narrower than the diagonal grid. Strands in adjacent units go in the opposite direction to each other.

5. Join the strands up. When they reach a wall, they are deflected through 90°, and make a U-turn at the corners. Two rules are changed here – the corners are rounded and not pointed, and the strand goes through the openings at A and B to form a point.

6. When you have made two hearts from a continuous strand, draw in the outline, erase the pencil lines and colour with watercolour pencils. Wet the pencil to achieve a darker shade.

Variation on Heart-twining Knot

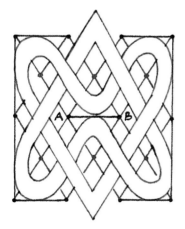

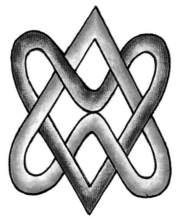

The two hearts in the knot above, are made from a continuous strand. In the variation here, two separate strands are entwined. This design is created by placing a wall at A–B, deflecting the strand through approximately 70° and breaking it.

Borders

Knotwork borders are based on a square or rectangular grid. When designing a border, divide the length required into a whole number of units. The basic grid shown below can be extended to fit any length, width or shape.

Basic Grid

 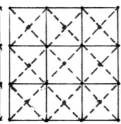 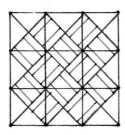 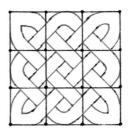 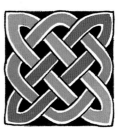

1. Draw a square of 3 x 3 units. Place a dot at the corner of each unit.

2. Place a dot in the centre of each of the nine units and draw a diagonal grid (pink).

3. Draw a strand (green) inside and narrower than the diagonal square. Strands in adjacent squares go in the opposite direction to each other.

4. Join the strands up. When a strand reaches a wall it is deflected through 90°; when it enters a corner, it makes a pointed U-turn.

5. Complete the motif by colouring with gouache and filling in a black background. (This pattern can be seen as a continuous border on the front cover of this book.)

Variations on the Basic Grid

1. Place walls at intervals within a rectangle to vary the pattern and make a larger, more interesting area of interlaced knotwork.

2. Draw the strands (green) within the diagonal grid (pink) as before.

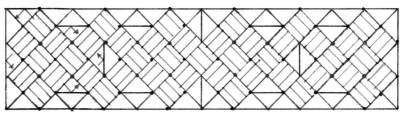

3. Join the strands up and deflect through 90° at each wall (black). Corners are made in the same way as in the basic grid above.

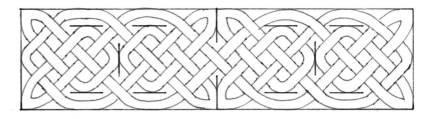

4. Complete the border then paint with yellow, light blue and green. Add an indigo background. (This pattern can be seen as a continuous border on page 41.)

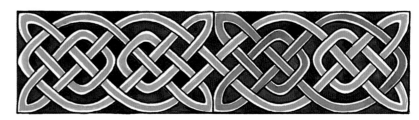

Figure-of-Eight Knot Pattern

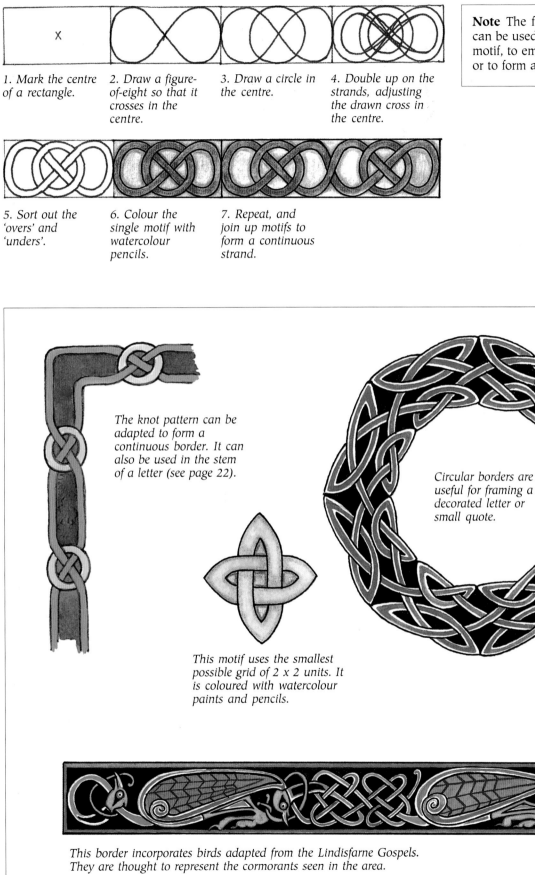

X

1. Mark the centre of a rectangle.

2. Draw a figure-of-eight so that it crosses in the centre.

3. Draw a circle in the centre.

4. Double up on the strands, adjusting the drawn cross in the centre.

Note The figure-of-eight knot can be used as a single knot motif, to embellish a plain letter, or to form a continuous strand.

5. Sort out the 'overs' and 'unders'.

6. Colour the single motif with watercolour pencils.

7. Repeat, and join up motifs to form a continuous strand.

The knot pattern can be adapted to form a continuous border. It can also be used in the stem of a letter (see page 22).

Circular borders are useful for framing a decorated letter or small quote.

This motif uses the smallest possible grid of 2 x 2 units. It is coloured with watercolour paints and pencils.

This border incorporates birds adapted from the Lindisfarne Gospels. They are thought to represent the cormorants seen in the area.

Layout

Even a simple greeting on a card requires planning, so that the writing looks attractive and visually balanced against the size and shape of the card.

There are various types of layout which can be used, and the best option is arrived at by a process of 'cut and paste'. This then provides a blueprint for the finished piece. Even large and complex calligraphic panels can be seen to contain a combination of more simple arrangements.

The amount of white space around the work is vital to the visual balance of the design. Margins which are too small make the writing appear too cramped. The amount of space needed around the work is related to the space within, i.e. light writing would need more space around it. Layouts should always be assessed by placing strips of card around the work as shown. Doing this will often show up unbalanced areas of the design which might otherwise go unnoticed.

As a general rule, the strong horizontal character of uncials needs generous interline spacing of twice the x-height. The purpose of the interline spacing is to emphasise the horizontal lines for ease of reading. The amount allowed will depend upon the weight, size and quantity of text. Short lines of writing need less interline space than long ones.

1. Write the text in your chosen pen size. Photocopy four times.

2. Number the lines on the photocopies. Take one copy and place it on a cutting mat. Cut the text into lines using a craft knife and ruler, or use scissors.

3. Rule a generous left-hand margin on to layout paper. Mark and rule guide lines, using the same ruling as your original text. Assemble the strips into the first layout shown opposite. Glue in place using a repositionable glue stick or roller.

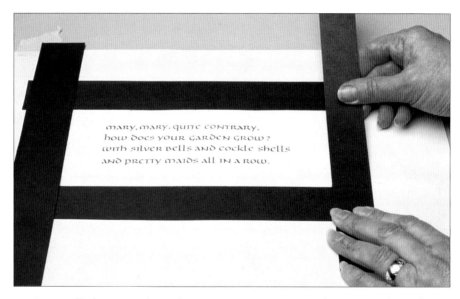

4. Erase all the pencil marks. Put margins around your work and use this frame to check how the arrangement works. Repeat steps 2–4 with the other layouts. When you have decided upon a layout, transfer the measurements and copy the text on to good paper, following your chosen format.

Types of Layout

The choice of text will often make some decisions for you. For instance, the example used here is better suited to a horizontal format (sometimes known as landscape). If a vertical (or portrait) format had been required, the lines would have been divided to make them shorter, thereby increasing the number of lines. Although this arrangement might be satisfactory visually, it could impair the flow of the words when being read.

mary, mary. quite contrary,
how does your garden grow?
with silver bells and cockle shells
and pretty maids all in a row.

Ranged Left

This is the easiest layout. All lines start from a vertical left-hand margin. Alternate lines can be indented as a variation of this layout.

mary, mary. quite contrary,
how does your garden grow?
with silver bells and cockle shells
and pretty maids all in a row.

Centred

Lines of text are equally balanced around a central vertical line. The writing needs to be reproduced carefully and exactly for the finished piece.

mary, mary. quite contrary,
how does your garden grow?
with silver bells and cockle shells
and pretty maids all in a row.

Ranged Right

All lines finish at a vertical right-hand margin. Again, accuracy is needed when writing as a finished piece.

mary, mary. quite contrary,
how does your garden grow?
with silver bells and cockle shells
and pretty maids all in a row.

Asymmetric

This layout is freer and less formal in character. Although there is a strong central vertical axis, no two lines begin and end in the same place, and they are visually balanced around the axis.

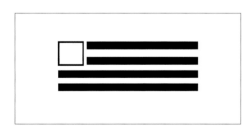

These line drawings show the possible positions for a decorated initial.

Writing with Gouache

The sooner you can put your new skills into practice, the better. It is best to start with small projects such as envelopes, bookmarks, cards, quotations and short rhymes. Such projects are a wonderful opportunity to add another dimension to your lettering with the use of colour. You can buy pre-mixed colours, or you can mix your own from a basic palette. Tints and shades can be achieved using zinc white and lamp black. Heavyweight cartridge paper and green gouache were chosen for this nursery rhyme, which has been 'dressed up' with a decorated initial and border.

In order to write with gouache, it needs to be mixed with water to the consistency of thin cream. A few drops of gum arabic will prevent smudging when the writing is dry, and some colours benefit from the addition of a few drops of ox gall liquid to aid the flow. Although this consistency is similar to that of bottled ink, gouache does not always behave like ink, and some colours are easier to write with than others. It is therefore a good idea to write with gouache as often as you would use ink. Experience and familiarity are the best antidotes to any problems. As a general rule, if the gouache is not flowing properly it is simply that the mix is wrong, i.e. either too dry or too wet, and you need to continue testing the mixture whilst gradually altering the quantities of water, gum arabic and ox gall. Ensure that the gouache is well mixed.

Gouache tends to dry in the nib more readily than ink, and the mixture can lose water through evaporation if it is in a palette. Always mix plenty of colour, as you may not be able to repeat the mixture exactly should you run out. Any leftover gouache can be kept covered and used again.

You will need
Gouache paint
Watercolour pencils
Ox gall
Gum arabic
Small, old paintbrush
Palette
Tracing paper
Coloured technical drawing
 pen
No. 3 calligraphy pen
Dark-coloured card
 for margins
Heavyweight cartridge paper
Pencils

Note A basic palette can be made up from cadmium red deep, scarlet lake, ultramarine deep, cerulean blue, lemon yellow and cadmium yellow deep.

Below
Nursery rhyme
80 x 205mm (3 x 8in)

The border for this piece of calligraphy was based on a Tree of Life design. It was coloured with watercolour pencils. The calligraphy was written in gouache on heavyweight cartridge paper.

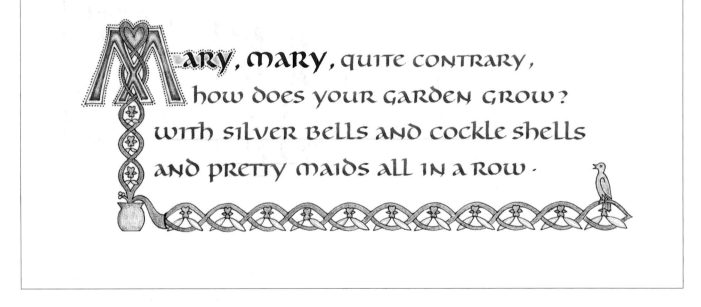

Artwork for Nursery Rhyme
*Adjust the size on a photocopier
to suit. Make a tracing of the
design and use this to help plan
the layout of the text (see pages
28–29).*

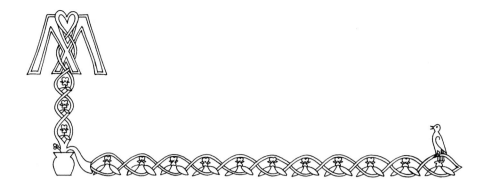

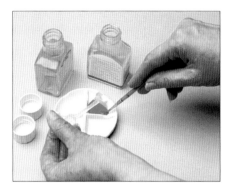

1. Choose your paint colour.
Squeeze the paint into a small
well in your palette and add a
couple of drops of gum arabic
and ox gall, then sufficient water
to achieve the consistency of
thin cream. Use an old paint-
brush to mix the gouache well.

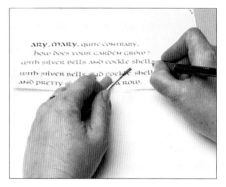

2. Having decided upon the
layout (see pages 28–29), and
ruled up accordingly (see page
13), use a brush to fill the pen
with the gouache mixture (see
page 16). Write out your text.
Place the layout guide directly
above or below the line you are
writing to ensure you do not
miss any letters out!

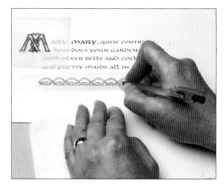

3. Place the tracing of the
decoration over the text to
decide on the best position and
then trace it down (see pages
20–21).

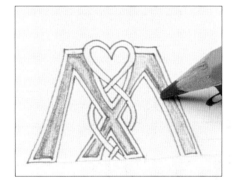

4. When the decoration has
been outlined and the pencil
erased, colour it in using
watercolour pencils or paint.

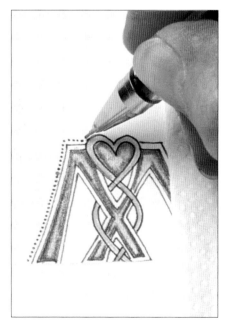

5. Touch up the outline again if
necessary and use a coloured
technical drawing pen to add
fine dots around the initial and
the first word. Fill in the
counterspaces with a
watercolour pencil. Use strips of
dark-coloured card to help you
define the final margins (see
page 28). Adjust if necessary.

Note If you make a mistake
when working with gouache, try
using a touch of process white to
correct it.

CONTEMPORARY UNCIALS

The beauty and rhythm of the uncial hand can be extended by developing variations of the basic script. These variations may be more appropriate in freer, more informal work, whilst still retaining the essential uncial character.

Variations are based on alterations to the weight, angle and form (see page 12). You should be able to write the basic script confidently before you attempt this exercise. Work in a logical sequence without changing too many things at once.

Changing Weight

The weight refers to the thickness of stroke relative to the height of the letter. Here the underlying form is unchanged (the skeleton form is on the left and in black). The weight has been progressively increased from left to right by using larger pens. The counterspace decreases as the weight increases.

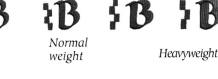

Lightweight

Normal weight

Heavyweight

Changing Form and Weight

Here, the normally slightly wide circle has been laterally compressed. Each letter of the alphabet has to be treated in the same way to maintain the essential family resemblance. The x-height is five nib widths which allows more white space inside the letter.

Original form, with 22° pen angle

Laterally compressed form, with 22° pen angle

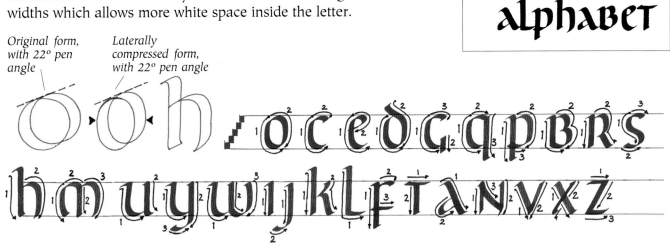

Note Flatter is fatter! A flat pen angle gives a wider vertical stroke (see page 12). The same principle can apply to the letters: narrow compressed forms are often written with a steeper pen angle.

Changing Form and Pen Angle

The main difference here is that the arch is a branching arch made in one movement following the downstroke. It does not involve a pen lift and separate stroke as before. The pen angle is higher to accommodate this action. The shape is subtly changed to a softer oval, but the letters do not slant.

30° pen angle

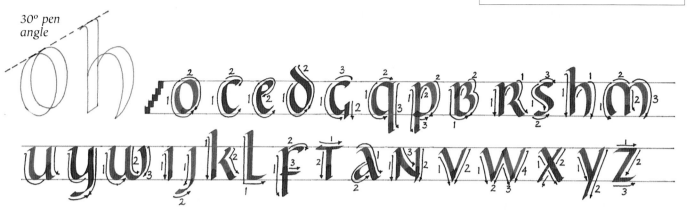

Italicised Variations

The italic form lends itself to the widest possible range of variations, from compressed to extended, light to heavyweight. This italicised variation has a lower branching arch and the 'O' form has been adjusted to match this shape. The letters have a slant of 5° from the vertical, which gives a more informal appearance.

40° pen angle

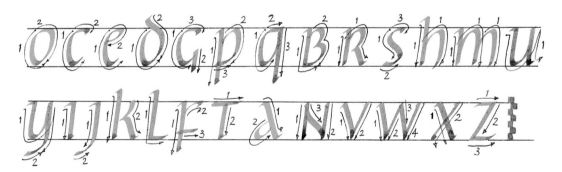

20° pen angle

> Jackdaws love my big sphinx of quartz

f Jackdaws Love my big sphinx of quartz

22° pen angle

٦ jackdaws Love my big sphinx of quartz

Alternative Letterforms for use with Contemporary Uncials

Moving away from the traditional uncial alphabet allows for some variations to individual letters. This allows you to achieve greater freedom of style and create a contemporary look.

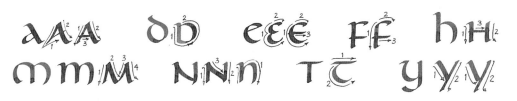

Variations with Colour

Blocks of text provide a wonderful opportunity to experiment with colour, as these examples show.

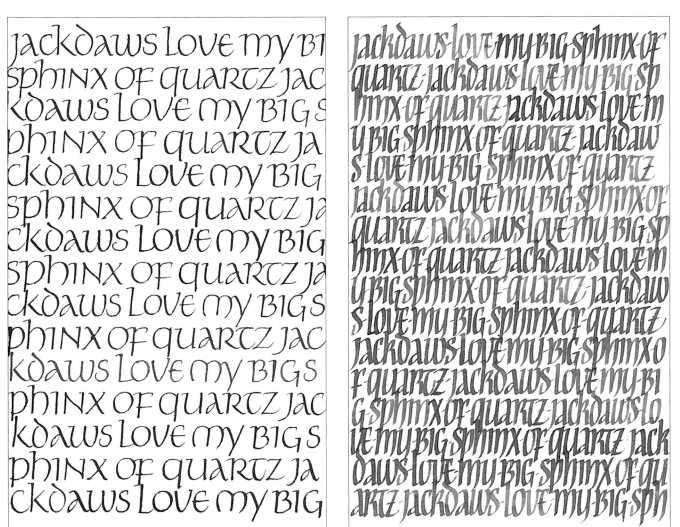

Texture
Lightweight open and mediumweight compressed variations create two very different textures when written in quantity.

Colour Change

This gradual colour change is achieved by feeding subsequent colours into the pen before the previous one is exhausted, and without cleaning the pen.

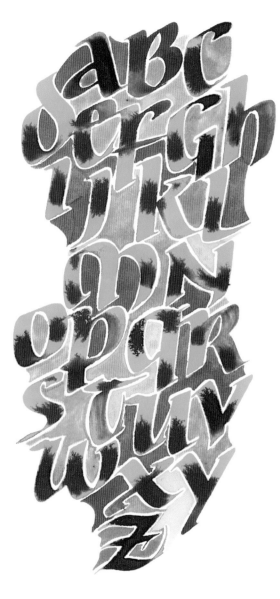

Wet into Wet

These letters were written with turquoise calligraphy ink, then, while the ink was still wet, magenta was touched in with a brush. The counterspaces were painted with dilute mixtures of the colours.

Layering

This very diluted Payne's grey watercolour background was overwritten with turquoise and red calligraphy ink, when dry.

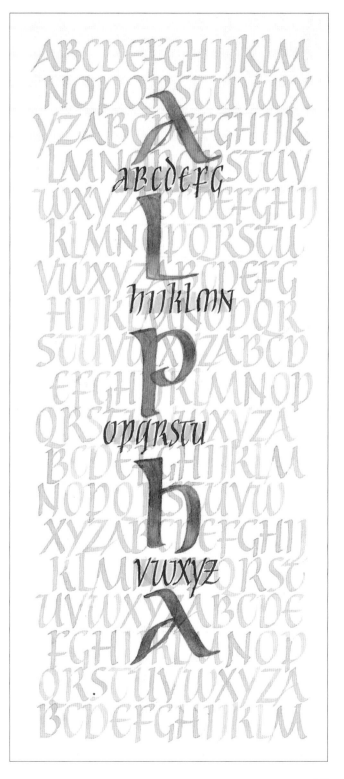

Moving On

A more complex project is still approached in the same way as a simple one (see pages 28–31). The various design elements are experimented with separately and then combined as a paste-up to provide a draft for the finished piece. Initially, layout possibilities may seem limitless, but the text will begin to take shape as you work on it. You may find you wish to change some of your first ideas in the light of your trials, the solution to each element helping to resolve the next.

This piece is of medium size, portrait format, and traditional in design. It has a knotwork border and decorated initial letter.

> **Note** The discipline required to establish the basic skills of lettering and design provides the launch pad for more innovative work and allows the freedom to develop a more individual style.

Rough Ideas

Write out the text in pencil and experiment with various arrangements as thumbnail sketches. These are very quick to do, and enable you to get a feel for how the elements of the design relate to each other.

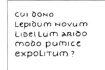

Writing Trials

Decide on the size, weight and spacing of the writing for the various elements: in this example there is the main text, the heading, the translation and the credit. It is best to begin with the main text as this is the largest and most important element – everything else needs to complement and balance that.

The Main Text

> ✓ Lepidum Novum Libellum arido
>
> ✓ Lepidum Novum Libellum arido

There is not much text, with only one or two words on each line. The writing therefore needs to be very strong so I chose the first variation. The text is written with a 1½ nib at a height of three nib widths.

The Translation

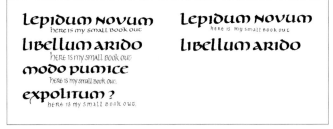

Each trial had to be assessed against the main text. I chose the fifth variation. This provides a good contrast with the main text because it is lighter in weight and has a narrower form. A generous letter spacing was used to stop the lines from becoming too dense.

The Credit

I decided not to use any of these experiments, as I felt it would be better to work it in the same form as the translation.

The Heading

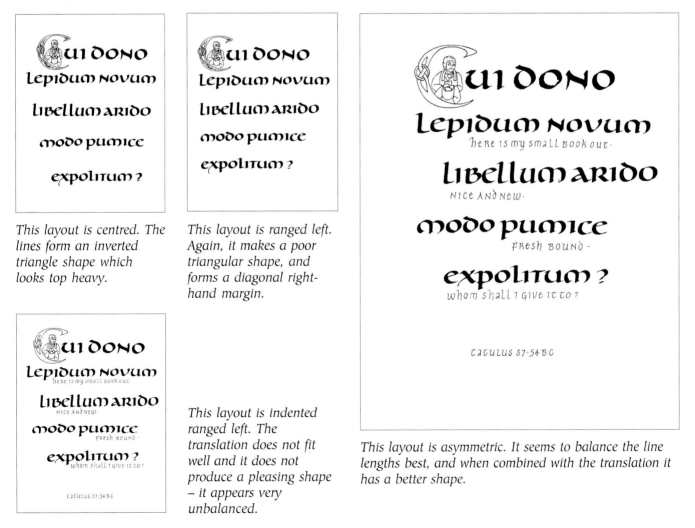

The fourth variation was chosen. It was in keeping with the style of the main text, offering sufficient contrast in size to provide a heading, but without being too dominant.

Layout Trials

Choose your decorated letter and trace it on to tracing paper (see pages 20–21). I chose a simple decorated initial adapted from the *Book of Kells,* as I also wanted to include a decorated border. Experiment with different layouts (see pages 28–29), remembering to include the decorated letter. When you are happy with the layout, rule it up on to good paper.

This layout is centred. The lines form an inverted triangle shape which looks top heavy.

This layout is ranged left. Again, it makes a poor triangular shape, and forms a diagonal right-hand margin.

This layout is indented ranged left. The translation does not fit well and it does not produce a pleasing shape – it appears very unbalanced.

This layout is asymmetric. It seems to balance the line lengths best, and when combined with the translation it has a better shape.

37

Colour Trials

Experiment with different colours for the text, the decorated letter and the border. When you have decided on the colours, write out the text. Work logically from the top. In this example I began with the heading, then the main text, then the translation, then the credit. It is important to do all the writing before adding any decorative elements in case you make a mistake in the text.

Colour trials on capital

Colour trials on border

Colour trials on text

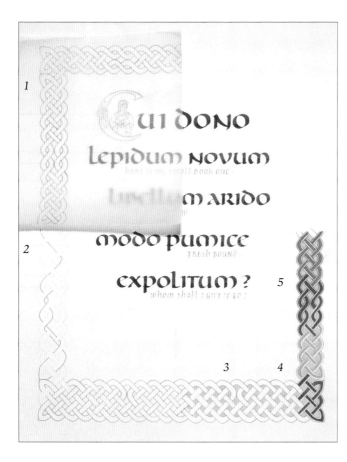

The Border

1. Trace the border. (Here, the picture shows the border taped in position ready for tracing down.)

2. Outline the border using a technical drawing pen. Erase the tracing. (The picture shows the border partially outlined.)

3. Paint the background using gouache and a No. 1 brush.

4. Paint the strands, leaving a narrow white margin between the outline and the colour.

5. Go over the outline with a black technical drawing pen to complete the piece.

Opposite

The Finished Piece

220 x 280mm (8½ x 11in)

This traditional design includes a knotwork border and decorated initial letter. It uses non-waterproof Indian ink, sepia calligraphy ink and gouache on heavyweight cartridge paper.

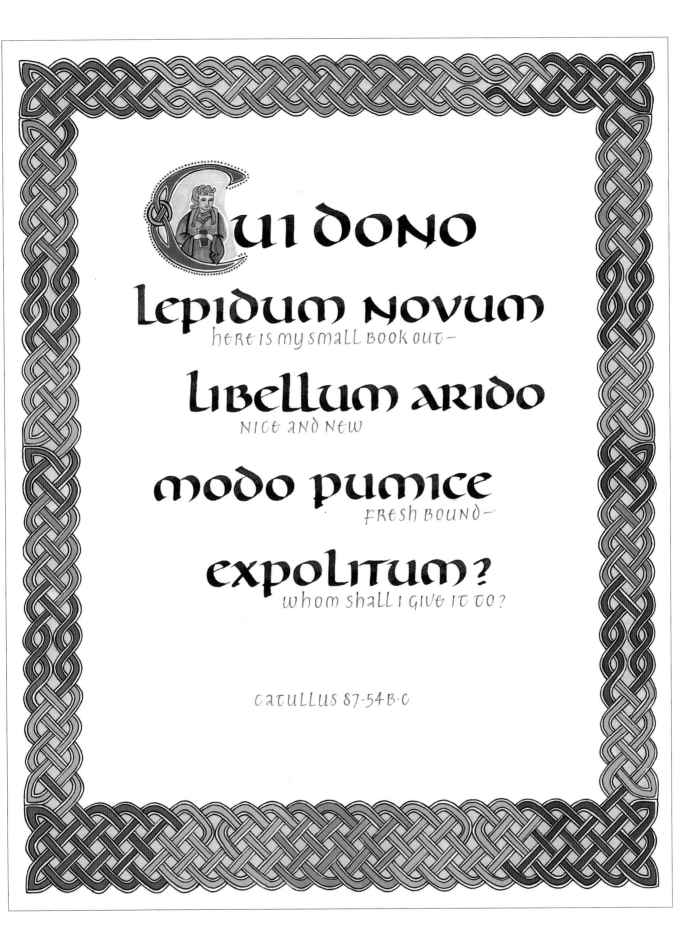

Cui dono

lepidum novum
here is my small book out–

libellum arido
nice and new

modo pumice
fresh bound–

expolitum?
whom shall i give it to?

Catullus 87-54 B·C

GALLERY

This section includes examples of work both traditional and contemporary in flavour, but all sharing a common origin. They provide a source of inspiration, and also demonstrate the amazing versatility of calligraphy.

Clockwise from top left:

Christmas Card

White and gold gouache on Indian handmade paper, collaged on to corrugated card.

Birthday Card

Gouache on Indian handmade straw paper.

Key Ring

Gouache on Ingres paper, with commercially available plastic key ring blank.

Handmade Book

Fabric paint, gouache and watercolour pencil on mouldmade paper. Japanese stab binding with embroidery thread and beads.

Place Card

Gouache on marbled paper.

Envelope

Large letters written using a five-lined music pen and then coloured with crayons; smaller writing in gouache.

New Home Card

Gouache on Ingres paper, collaged on to Thai tissue and heavyweight cartridge paper.

Bookmark

Gouache on calfskin vellum, with a beaded tassel made from embroidery silk.

Coaster

Letter made with double pencils and gouache on green card, with commercially available plastic coaster blank.

Parcel

Gouache on kraft paper, gold ruled with technical drawing pen. Ribbon made from unbleached calico. Writing in gouache. Tassel from embroidery silk and gold thread.

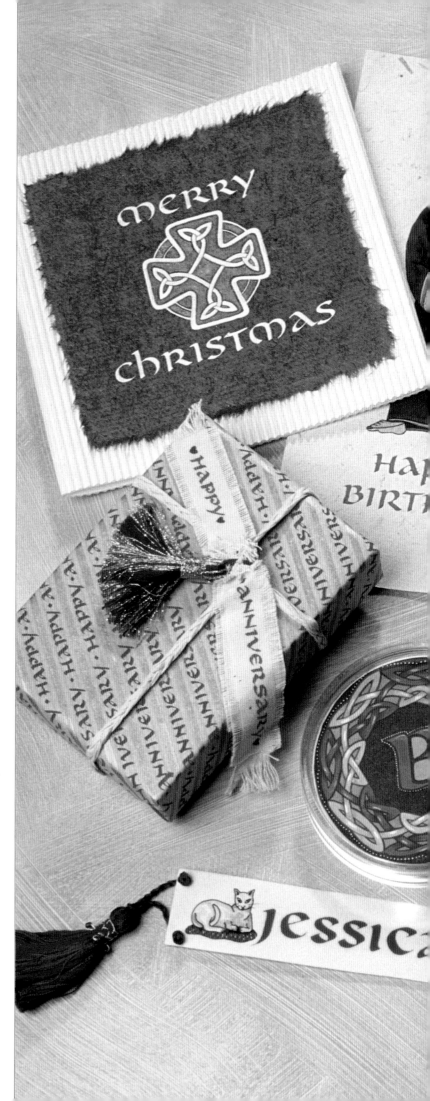

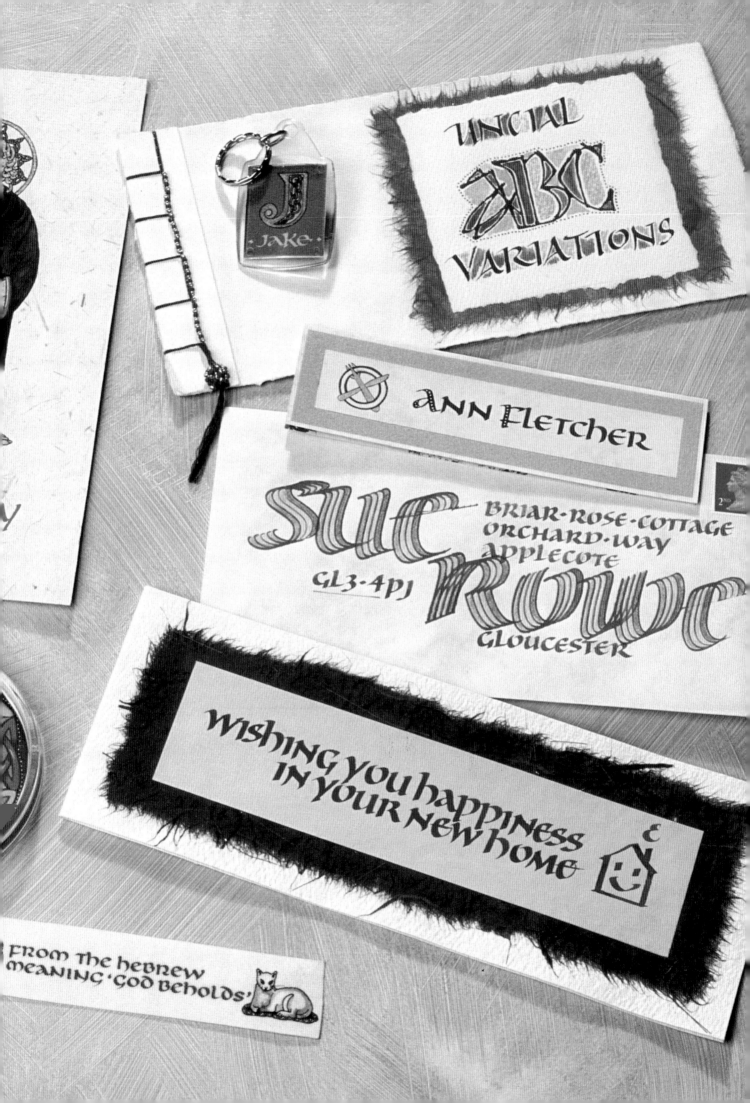

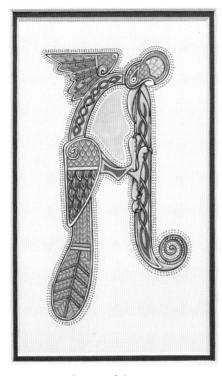

Decorated Initial 'A'
Letter dimensions 62 x 125mm
(2¼ x 5¼in).

Gouache on HP watercolour paper.

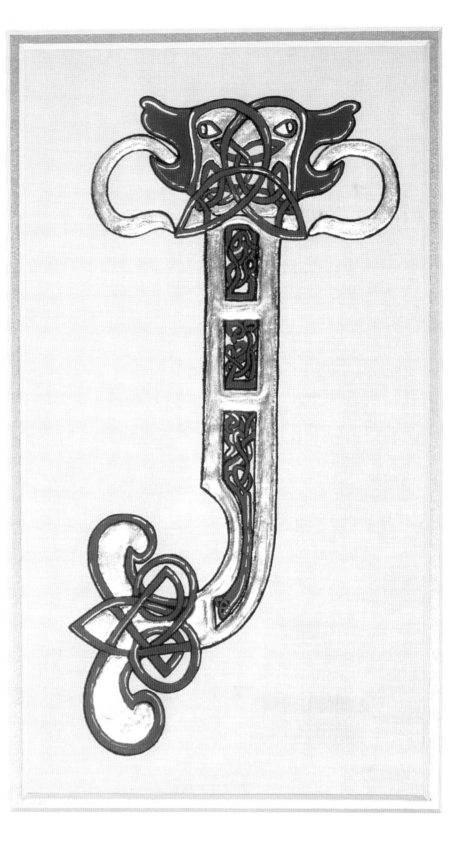

Decorated Initial 'J'
Pamela Finney 1997
Inner frame 254 x 152 (10 x 6in)

Gold leaf on a PVA base and
gouache on unbleached calico.

Hindu Cradle Song
133 x 202mm (5¼ x 8in)

Watercolour background on HP watercolour paper, dusted with gold
powder. White gouache and transfer gold leaf on PVA base.

FROM GROVES OF SPICE
O'ER FIELDS OF RICE,
ATHWART THE LOTUS STREAM,
I BRING FOR YOU
AGLINT WITH DEW

A LITTLE LOVELY DREAM.

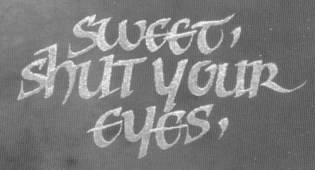

SWEET,
SHUT YOUR
EYES,

THE WILD FIREFLIES
DANCE THROUGH THE FAIRY NEEM,
FROM THE POPPY BOLE
FOR YOU I STOLE

A LITTLE LOVELY DREAM.

HINDU CRADLE
SONG

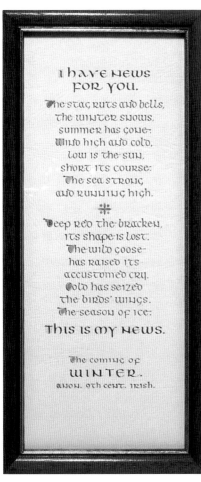

I Have News For You

Inner frame 120 x 295mm
(4¾ x 11½in)

Chinese stick ink and gouache on handmade paper. From page 64, A Celtic Miscellany, Kenneth Hurlstone Jackson, Penguin Books, 1971.

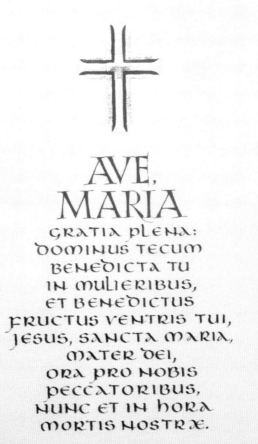

Ave Maria

Text area 85 x 165mm (3¼ x 6½in)

Chinese stick ink, gouache and gold leaf on a gum base on artificial parchment.

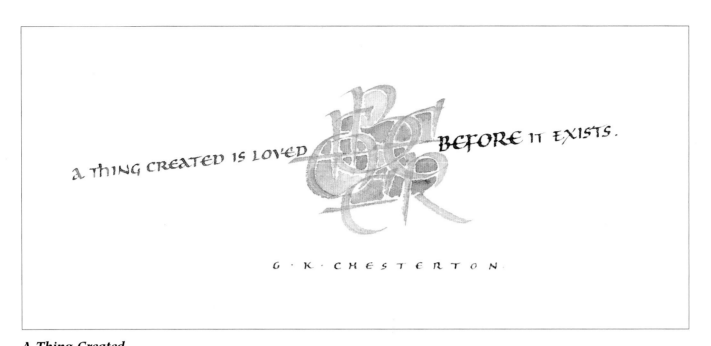

A Thing Created
Peter Thornton 1998 • 180 x 70mm (7 x 2¾in)

Uncial variations using watercolours on handmade paper.

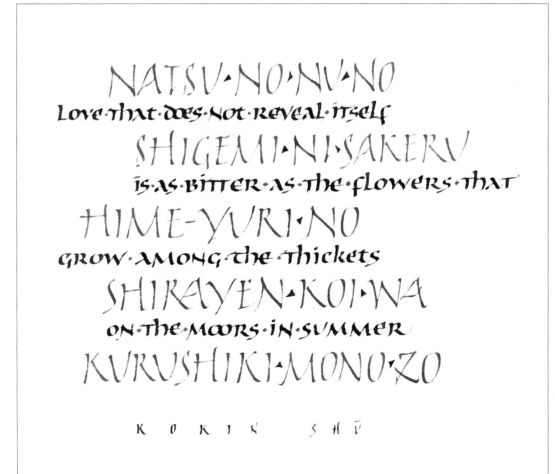

**Love That Does
Not Reveal Itself**
*Peter Thornton 1998
180 x 165mm (7 x 6½in)*

*Combined modern-
ized uncials and
Roman capitals
using walnut ink on
handmade paper.*

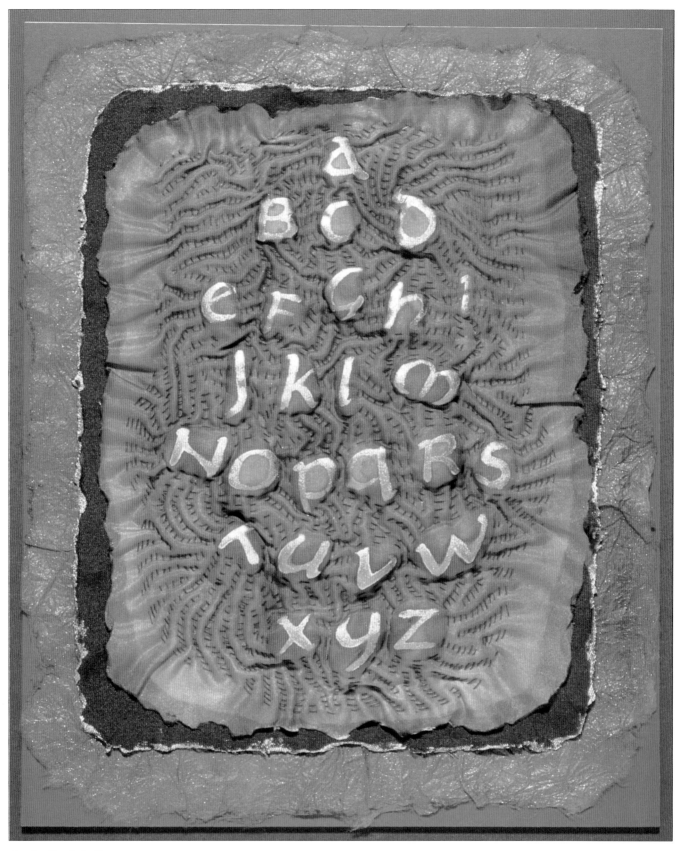

Quilted Alphabet

Melanie Mortimer 1998 • Overall size 245 x 290mm (9¾ x 11½in)

*Kantha is a traditional Indian method of quilting which has been used here
to provide a silk background to uncial letters painted with bronze powder
and gold size.*

46

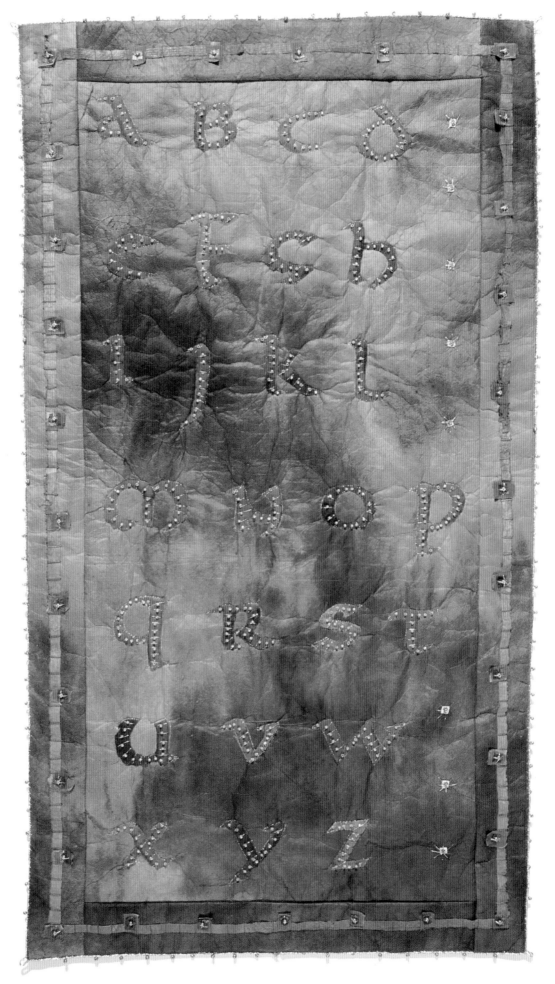

Appliquèd Alphabet

Beryl Taylor 1998
325 x 585m (13 x 23in)

Letters initially shaped
using double pencils.
Padded then appliqued
with gauze, gold
thread and beads on to
dyed paper.

Index

Bibliography

Celtic Knots: Techniques and Aesthetics,
Mark Van Stone, Alphabet Studio, USA, 1992

Celtic Art: The Methods of Construction,
George Bain, Constable, 1982

The Celtic Design Series,
Aidan Meehan, Thames & Hudson

Writing, Illuminating and Lettering,
Edward Johnston, A & C Black, 1994

The Book of Kells,
Peter Brown, Thames & Hudson, 1980

The Lindisfarne Gospels,
Janet Backhouse, Phaidon, 1981

Codices Latini Antiquiores, Vol. II, E. A. Lowe
Oxford University Press, 1952

Historical Scripts, Stan Knight,
Oak Knoll Press, 1999

A Book of Formal Scripts, John Woodcock,
A & C Black, 1992

Where to See Historical Manuscripts

The Lindisfarne Gospels
British Library, England

The Lichfield Gospels
Lichfield Cathedral, England

The Hereford Gospels
Hereford Cathedral Library, England

The Macdurnan Gospels
Lambeth Palace Library, England

Cassiodorus, Commentary on the Psalms
Durham Cathedral Library, England

The Barberini Gospels
Vatican Library, Vatican City

The Echternach Gospels
Bibliothèque Nationale, France

Book of Durrow and Book of Kells
Trinity College, Dublin, Ireland